French Impressionists

GREAT ART OF THE AGES

———————

French

GREAT ART OF THE AGES

Impressionists

Text by HERMAN J. WECHSLER

Harry N. Abrams, Inc. Publishers New York

MILTON S. FOX, *Editor-in-Chief*

Standard Book Number: 8109–5112–6

Library of Congress Catalog Card Number: 69–19707

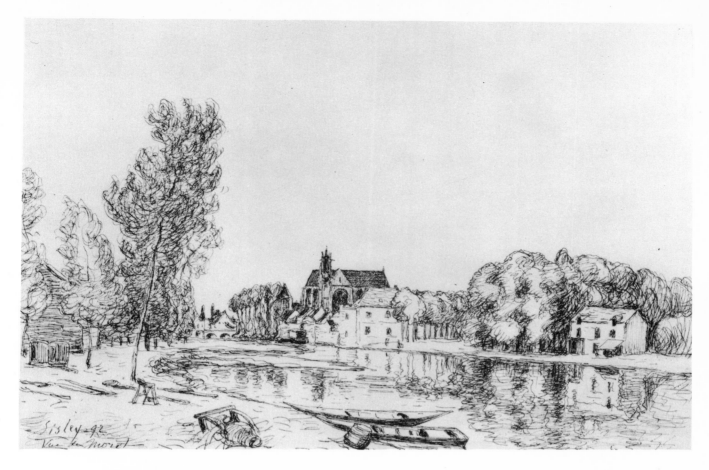

French Impressionists

TODAY THE TERM IMPRESSIONISM has not only found its way into the language of critic and layman alike, but it immediately evokes images of a series of brilliant canvases by painters who are now being called "traditional"—sometimes "old masters"! Yet less than one hundred years ago, the efforts of these same artists were considered "outlandish" and "insults to the painter's craft."

In the year 1874, a group of French painters who had had their offerings systematically rejected by the jury of the official Salon arranged their own exhibit on the vacated premises of the photographer Nadar, situated on one of Paris' busiest thoroughfares. Some thirty artists showed their wares, among them being Degas, Renoir, Monet, Pissarro, Cézanne, Sisley, and Berthe Morisot. Manet, although sympathetic to the group's activity, did not exhibit on this occasion.

The public and critics came to the humble quarters, paid a modest entrance fee, and experienced varied sensations. Some were honestly bewildered, others infuriated—the majority simply amused. Cézanne bore the brunt of the strongest insults, but it was one of Monet's pictures, entitled *Impression—Sunrise,* which gave the movement and the group its name, for a wit among the critics seized upon this title and labeled all the pictures shown as "impressionistic." Thus the word "impression-

ism," used first as a term of derision, was adopted by the very victims of this mockery as a label for their group and a proud banner for their rebellion. Their revolt was against the official art of the Salon, the Neoclassicism of the Academy, the elaborate set of ironclad rules which enslaved most of the artists of the day.

But the Impressionists were not alone in their century's rebellion. The great Ingres had thought of himself as a "revolutionary"; Courbet, with his stark realism, offended the official school; Delacroix had already deeply shocked the academicians by his "romantic" pictures; and Daumier went his quiet way to record and ennoble the everyday activity of the French bourgeoisie, ignoring the Greeks and Romans except in such instances as he chose to satirize their ancient glory.

Here, then, is a group of men of varying temperaments, dispositions, nationalities, and talents, who were linked together in a common effort to fight officialdom, to experiment with new forms and theories, to express themselves freely in a manner unhampered by rules and traditions. The men represented in the following pages did not all give themselves completely and wholeheartedly to the tenets and practices of Impressionism. Only two or three among them clung tenaciously to its theories in their purest form. Such were Sisley, Pissarro, and Monet. But all the other artists dealt

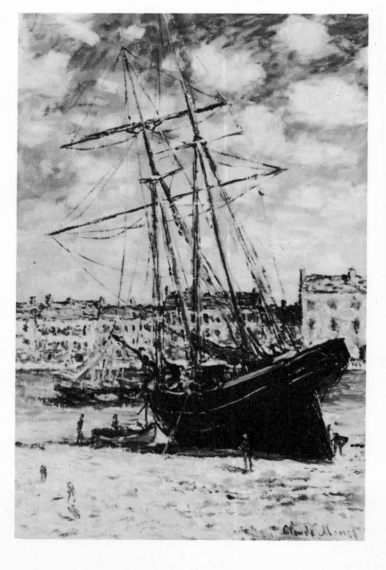

CLAUDE MONET
STRANDED BOATS
Collection Durand-Ruel, Paris

with in this portfolio were at some time close enough to the movement to warrant their being linked to the group. Cézanne and Van Gogh went through an Impressionistic phase. Seurat's Divisionism could not have come into being without the prior experiment. Manet, Degas, and Renoir produced some unforgettable canvases according to its formulas, and later evolved their personal styles. Gauguin, a broker and amateur painter, first met members of the group in nocturnal café gatherings, became one of the first collectors of their canvases, and, when he finally gave up business to paint professionally, was of course influenced by their teachings.

What, then, was the nature of this rebellion of the Impressionists, and what made their revolt so important a step in art history?

Let us consider first their choice of subject matter and their new attitude toward the contemporary world. Forgotten, or at least ignored, were the gods and goddesses of classical mythology and their fabled adven-

6

OPPOSITE PAGE:
CLAUDE MONET
FIELD OF POPPIES
Commentary on page 40

Field of Poppies

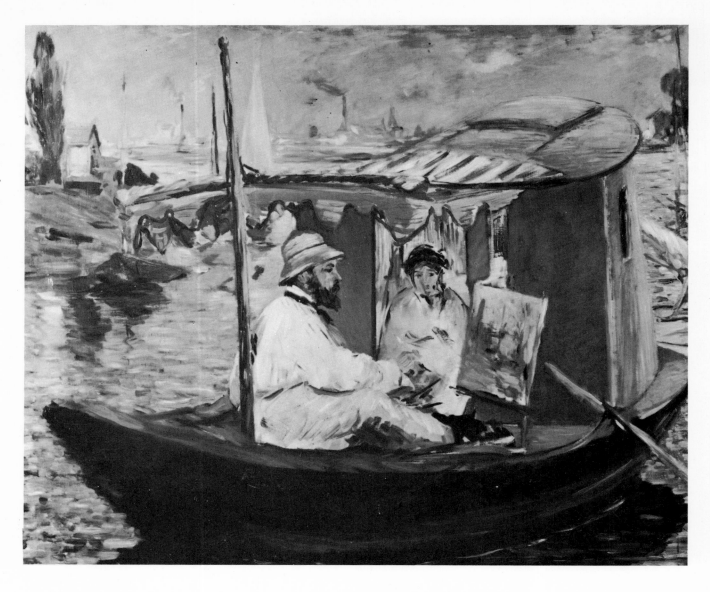

tures. Sometimes Renoir would label a nude *Diana* or *Venus*, to win her admission to the Salon. Actually she was a healthy, full-bodied French girl who had consented to pose for him. Ignored, too, were the battle scenes, the portraits of national heroes, the historical panoramas of the more tradition-minded artists. These painters began to look with unprejudiced eyes at the bustling life around them; they painted—as they saw them—the cafés and their habitués, prostitutes, vagabonds, drunkards, the middle-class business man. Influenced by the new art of the camera, they painted what we now call "candid" views—a moment of life seized and recorded—a man lifting a drink to his lips, a woman entering a doorway. People are often depicted moving *into* or *out of* the canvas, their bodies or faces cut off by the limiting frame. It is as though the artist had accidentally come upon some scene which intrigued him and had quickly "caught it" and noted it down. Often, of course, this was carefully "worked up" at the studio, but the notes, written or remembered, were made at the moment of observation. Also, the trivial was accepted as subject matter—a single dead fish on a platter, a few pieces of fruit, a spray of flowers. These men, too, sought for inspiration and

ideas everywhere—from the Japanese print, exotic native carvings, tiles and ceramics from the Near and Far East, objects which we often see in the backgrounds of their pictures.

But in the realm of color, the changes seemed more extreme to the old guard, for the Impressionists, often accused of being mere "scientists," investigated the new laws of optics, "broke up" their colors, and juxtaposed dashes and blobs of paint so that the mixture was made in the eye of the observer and not blended on the palette. The painter's paraphernalia was carried out to the streets and fields, where the effect of sunlight was studied systematically. Monet painted the same scene over and over again, demonstrating how different was the aspect of the same object under changing conditions of light. He made his famous experiments with the façade of Rouen Cathedral; groups of haystacks in a field and the lily ponds of his own home also served as subject matter.

These are but a few of Impressionism's contributions. In the pages that follow, mention will be made of others. But the reader, if he has been moved by the pictures included in this portfolio—or made curious by the foregoing paragraphs—is urged to seek out other pictures by these men and the many thoughtful texts produced by the scholarly writers on Impressionism.

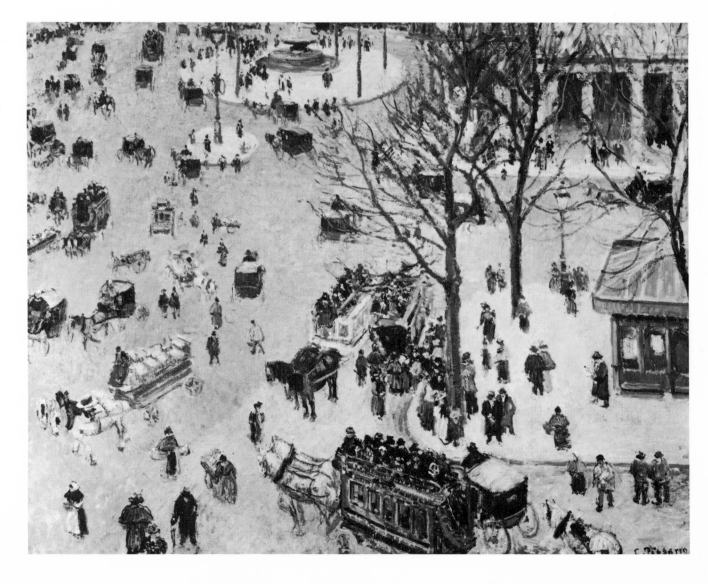

CAMILLE PISSARO
PLACE DU THÉÂTRE FRANÇAIS
Los Angeles County Museum
(De Sylva Collection)

ÉDOUARD MANET (1832–1883)

PAINTED IN 1874

Boating at Argenteuil

OIL ON CANVAS, $58\frac{5}{8} \times 51\frac{5}{8}''$

MUSEUM OF FINE ARTS, TOURNAI, BELGIUM

THIS PICTURE WAS PAINTED BY MANET about the time when he came into closer contact with Monet, Renoir, Sisley, and Pissarro. As has already been mentioned, Manet did not for long accept or follow the stricter tenets or formulas of Impressionism. We need only compare this truly "open-air" canvas with his earlier work to see how the colors have been lightened, how the shimmering effects of sunlight on the water and on the other objects which it bathes have been studied and rendered. Although the two figures form the central motif of the composition, the local background takes on real importance. Here Manet is far from the large silhouettes against dark backgrounds, which in derision had once been labeled "playing cards."

The figures themselves are less posed and suggest the more casual, unstudied attitudes which unobserved people assume naturally. Degas and Lautrec were destined to go much further in the direction of catching people off guard in the intimate, more honest, and often awkward positions of privacy.

Manet has given us here a magnificent example of his work during this period, a splendidly executed painting—surely among his best. Two people sit at the water's edge on a fine summer day. It is as though the artist felt called upon to convey the spirit of communion between them and the universe around them, a universe of color, harmony, and well-being. This was at least one aspect of Impressionism's legacy which Manet rendered supremely well.

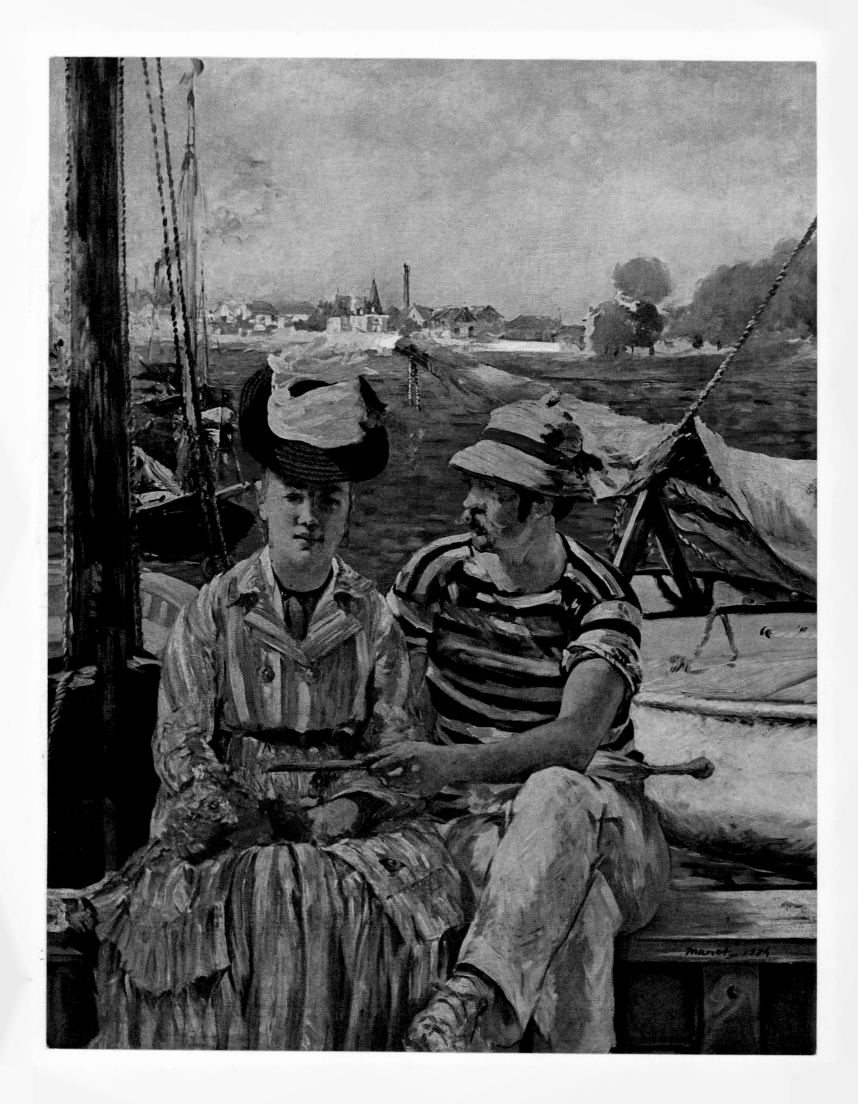

PAINTED IN 1876

Flood at Port-Marly

OIL ON CANVAS, 23⅝ × 31⅞″

MUSEUM OF IMPRESSIONISM, THE LOUVRE, PARIS

ALFRED SISLEY, A VETERAN OF the Impressionist group, never lived to see his many pictures of the countryside around Paris sought after, prized, and purchased. Although Renoir, Pissarro, and Cézanne were only acclaimed late in their lives, they did have the satisfaction of receiving awards, varied honors, or at least increased prices for their works. Sisley, however, died in 1899, tortured by a cancer of the throat, unaware, of course, that recognition would come within a few months of his passing, when Count de Camondo was to pay a comparatively huge sum for a single one of his canvases, enough money, in fact, to have permitted him to live comfortably for a long period.

Sisley was born of English parents in Paris, and when he was eighteen was sent off to England to begin a business career. But his love of France and the life of an artist brought him back to Paris, where he entered the studio of Gleyre. There he worked alongside Renoir and Monet until the day when they all left the atelier through dissatisfaction with Gleyre's uninspired instruction.

Sisley's early training had been along academic lines, and some of his pictures had been accepted by the official Salons. During this period he sold occasional paintings at distressingly low prices. When the Impressionists first organized their rebellion, however, he was one of their number, and with them was the recipient of all the vicious darts launched by the critics of the day. With family responsibilities driving him frantic, he offered to sell his works in lots of thirty for just about enough to subsist on for several months.

In spite of a dull, hard life, without adventure or excitement, Sisley managed to paint some of the most tender landscapes of the territory around Paris. Forests, riverbanks, bridges, avenues of trees, distant views of towns, observed in summer and winter, all served as models for his brushes. The bitterness which he came to feel for life and humanity never found expression in his poetic, often lyrical handling of a theme. Having lived the saddest life of any of the Impressionists, he none the less managed to leave the world some of its most vibrant, joy-giving pictures.

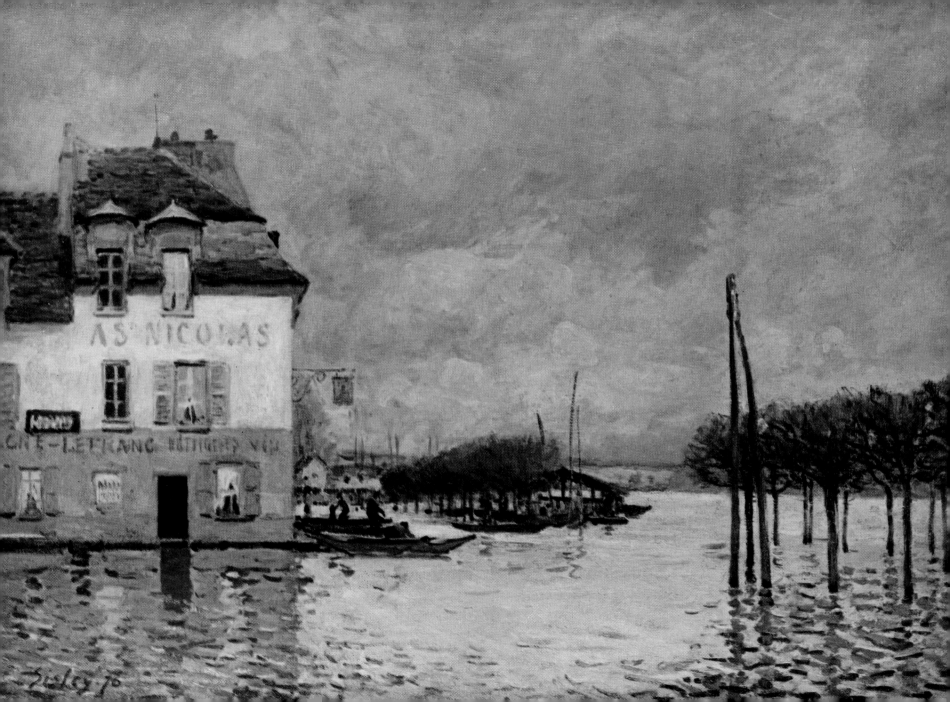

Flood at Port-Marly

PAINTED 1875–77

Café-Concert:

The Song of the Dog

GOUACHE AND PASTEL, 21⅝ × 17¾″

COLLECTION HORACE HAVEMEYER, NEW YORK

THIS PAINTING IS a brilliant impression of a moment; it is handled with a freedom that could only be called "impressionistic"; and yet it is not strictly an Impressionist painting. Although he associated with the Impressionists and exhibited in all but one of their eight shows, Degas always remained something of a stubborn traditionalist. He did not follow them in their loose drawing and atmospheric coloring, and more than once he expressed a frank distaste for "out-of-door" landscape painting, so central to the art of Monet, Sisley, Renoir, and Pissarro. If the term Impressionism can include psychological elements, however, then no one surpassed Degas in the ability to render momentary impressions of candid human gestures and movements. Here, under a dazzle of lights, he rapidly sets down in flowing brush strokes one of those vivid entertainment spectacles that so intrigued him.

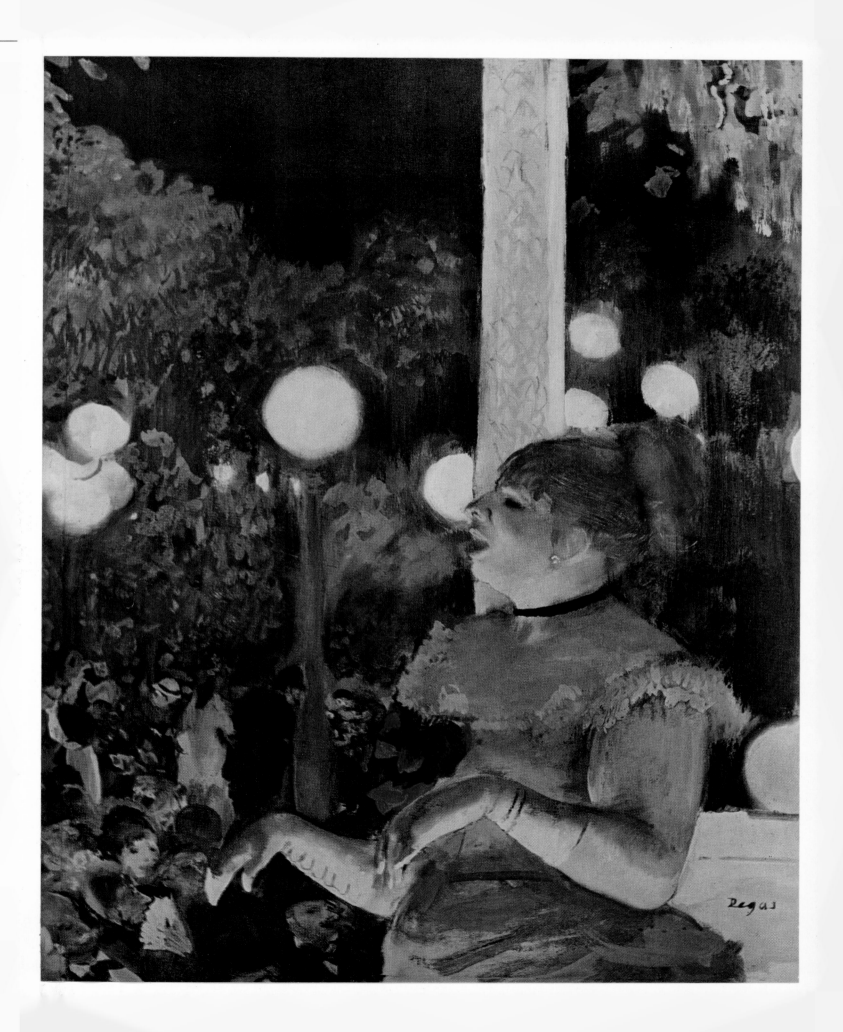

PAINTED 1878–79

Rehearsal of the Ballet on the Stage

OIL ON PAPER MOUNTED ON CANVAS, 21⅜ × 28¾″

THE METROPOLITAN MUSEUM OF ART, NEW YORK

(Gift of Horace Havemeyer, 1929. The H. O. Havemeyer Collection)

PROBABLY THE BEST KNOWN and most admired of Degas's paintings are those dealing with the ballet, those ballets which, in fact, were traditionally a part of the Paris Opéra. A constant visitor to the rehearsal hall, to the dressing rooms, and the regions backstage, where the last minute preparations for the performance took place, he rendered in countless sketches and paintings almost every aspect of this world of movement and color which he so dearly loved.

Adopting the honest, sometimes ruthless approach of his Impressionist confrères, he did not over-idealize the ballet dancer. He showed her for what she often was—a little country girl, coarse in appearance, awkward of gesture when caught off guard in the act of yawning, scratching herself, tying a shoelace. As in the present picture, he represents a rehearsal in progress, with some girls in the graceful poses of the dance while others relax and await their turn. The two figures on the right watch the rehearsal in the somewhat bored attitudes of the experienced, jaded onlooker.

Degas was very much influenced by the contemporary experiments in photography. Mention has already been made of the *candid* quality of his pictures, which removes them far from the Beaux-Arts and Academy tradition. He demonstrates here how the unplanned and the unposed offer unsuspected harmonies of color, of rhythm, of composition. Actually, this was less spontaneous than it appeared, for such a picture resulted from on-the-spot notes which were taken back to the studio and "worked up" into the finished, subtly calculated masterpieces with which his name is so generally associated.

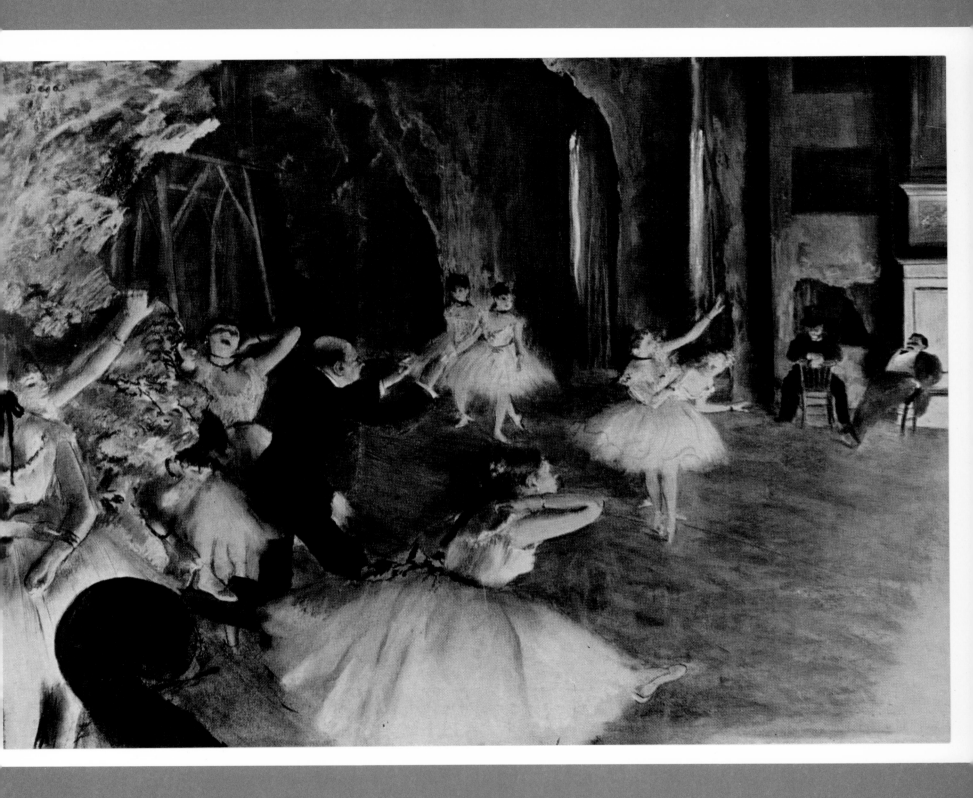

PAINTED IN 1881

Fruits of the Midi

OIL ON CANVAS, 20 × 27″

THE ART INSTITUTE OF CHICAGO

RENOIR EXHIBITED AN APTITUDE for drawing and painting at an early age, and when he was fourteen was already earning money as an apprentice in a china factory in Paris. Here he decorated blank forms with flowers, fruits, and idyllic scenes in the tradition of Boucher and Watteau. Later, when factory methods made the hand process uneconomical, he turned to the decoration of fans, boxes, and screens. He soon had enough money saved to enter the art classes of the academician Gleyre. His early experience with the brilliant enamel-like colors used in china painting he never forgot, and the present still life reflects these earlier predilections.

When he met Monet and Sisley at the Gleyre studio he listened carefully to their discussions and accompanied them often to the Louvre. Here he was a steady visitor and careful observer of the masterworks of the past, and ever afterwards repeated the dictum: "It is in the museums that one learns to paint . . . it is at the museum that one develops the feeling for painting which nature alone cannot give us."

Monet proved to be a most congenial companion and together they wandered through city streets and the countryside, turning out rapidly executed Impressionistic canvases. From such works Renoir turned to realistic and provocative nudes, and when he was thirty-two he not only had works accepted regularly at the Salon, but was commissioned to do portraits of fashionable Parisians at good prices. When, in 1874, the first Impressionist exhibit, already referred to, was held at Nadar's, seven of his works were included.

When he was almost forty years old he suddenly was beset by uncertainties concerning his art and returned briefly to the more classical style of Ingres. Later he visited Italy and was profoundly affected by the masterpieces of Rome, Florence, Venice, and Naples.

As has already been remarked, Renoir is the painter of "the good life," a man who expressed on canvas, and in the way he conducted himself, a genuine *joie de vivre*.

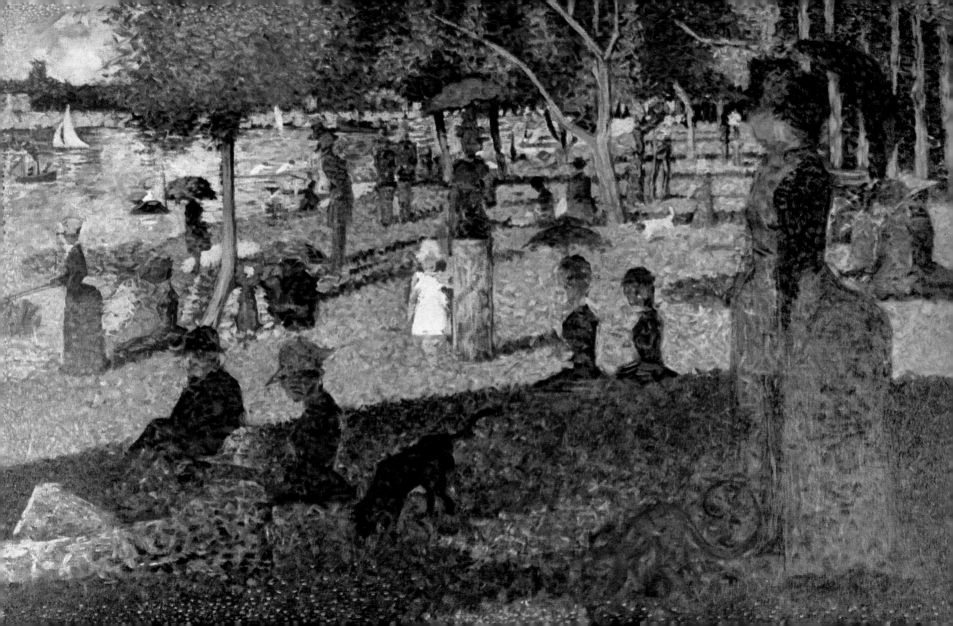

Sunday Afternoon on the Island of La Grande Jatte

PAUL CÉZANNE (1839–1906)

PAINTED ABOUT 1886–88

Mont Sainte-Victoire

OIL ON CANVAS, 26 × 35⅜″

COURTAULD INSTITUTE OF ART, LONDON

PAUL CÉZANNE BELONGS WITH THE IMPRESSIONISTS, not primarily because of his adherence to their theories, but rather because he was one of the rebels who submitted his work to hang in the first exhibit arranged by them. They called their organization the "Societé Anonyme des Artistes, Peintres, Sculpteurs, et Graveurs." It was only after the opening of this exhibit that the term "impressionism" was coined and the more ponderous label for the group was dropped. In this first showing the three pictures exhibited by Cézanne were judged by the public to be the most ludicrous of the lot.

Cézanne was born in the south of France, at Aix-en-Provence, and had his first training in the classics and in art at the local school. Before he was eighteen he won a second prize at the École des Beaux-Arts in Aix, and was determined to adopt art as his vocation. Urged by his father, he entered law school, but managed to spend most of his time painting. A young classmate from Aix, Émile Zola, was influential in attracting Cézanne to Paris, where he himself was already in residence. When he arrived in this city, he registered at the cheapest of the art schools, the Swiss Academy, where he met Pissarro. Rejected at the Beaux-Arts, he returned to Aix for a year, but soon reappeared in Paris and the Academy, where he met Renoir, Sisley, and Monet.

Cézanne was only a sporadic visitor at the Café Guerbois, where the militant younger artists used to gather. Later he met with them occasionally at the Nouvelle-Athènes, where he listened as they expounded their theories. In his art, however, he remained courageous and self-willed in spite of neglect by the officials and the public and in spite of the fact that his style was already at variance with those of his confrères.

To express the intent and function of his personal art, he used the same expression over and over again: "I must realize my sensations." The whole philosophy of his art was contained in that one phrase, if we understand the profound sense in which he employed it.

The picture included in this portfolio is typical of Cézanne's best in the realm of the landscape. He used to say: "Everything in nature must be treated as a cylinder or sphere." Essentially his method was one of simplification, a breaking down of what he saw into its fundamental elements. He broke completely with the Impressionists, finally saying that he was not concerned with "science."

With rare foresight, and in the realization that his work represented a cleavage with tradition, he often repeated: "I am the primitive of a new art!"

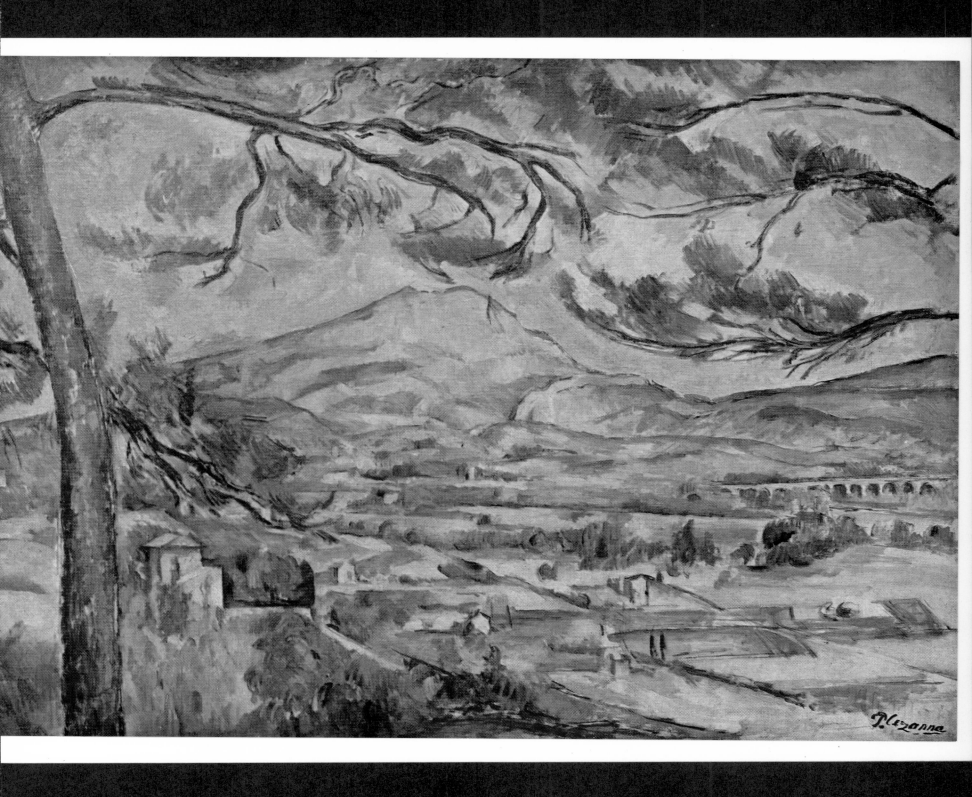

PAINTED IN 1888

Portrait of Armand Roulin

OIL ON CANVAS, 25⅝ × 21¼″

FOLKWANG MUSEUM, ESSEN

VINCENT VAN GOGH'S FIRST CONTACTS with art and artists came at a relatively early period in his career. At the age of sixteen he was employed by the firm of Goupil and Company, and in the capacity of salesman sold prints, drawings, and paintings of those artists represented in the shop's collection. He worked for a while in The Hague branch of Goupil and later on in the London establishment. His tastes were formed by contact with the old masters to be seen in the museums of these cities, and his first strong preferences were for traditional works. Of the more modern painters he most admired Millet and Corot.

One of the truly profound influences on his life came from his remarkable brother, Theo. The letters exchanged between the two men remain a real monument in the history of literature and form the basis of what we know today of Vincent's physical and inner life. From Theo, active in Goupil's Paris branch, Van Gogh first heard of the Impressionists, who were destined to have so definitive an effect on his point of view and style.

The subject of the portrait here reproduced was young Armand Roulin, son of the postman who also had posed a number of times for his friend Vincent. Van Gogh produced other portraits of Armand in this same year of 1888, but this is surely the finest. The darker, murky colors of earlier days have vanished. Influenced perhaps by the lessons learned from the Japanese wood-block prints of Hokusai and other masters, Van Gogh has laid the paint on thinly; the figure is outlined by strong lines which silhouette the subject against the lovely blue-green background. There is an authority and sureness lacking in the work of prior years. This is deservedly one of Van Gogh's most popular portraits.

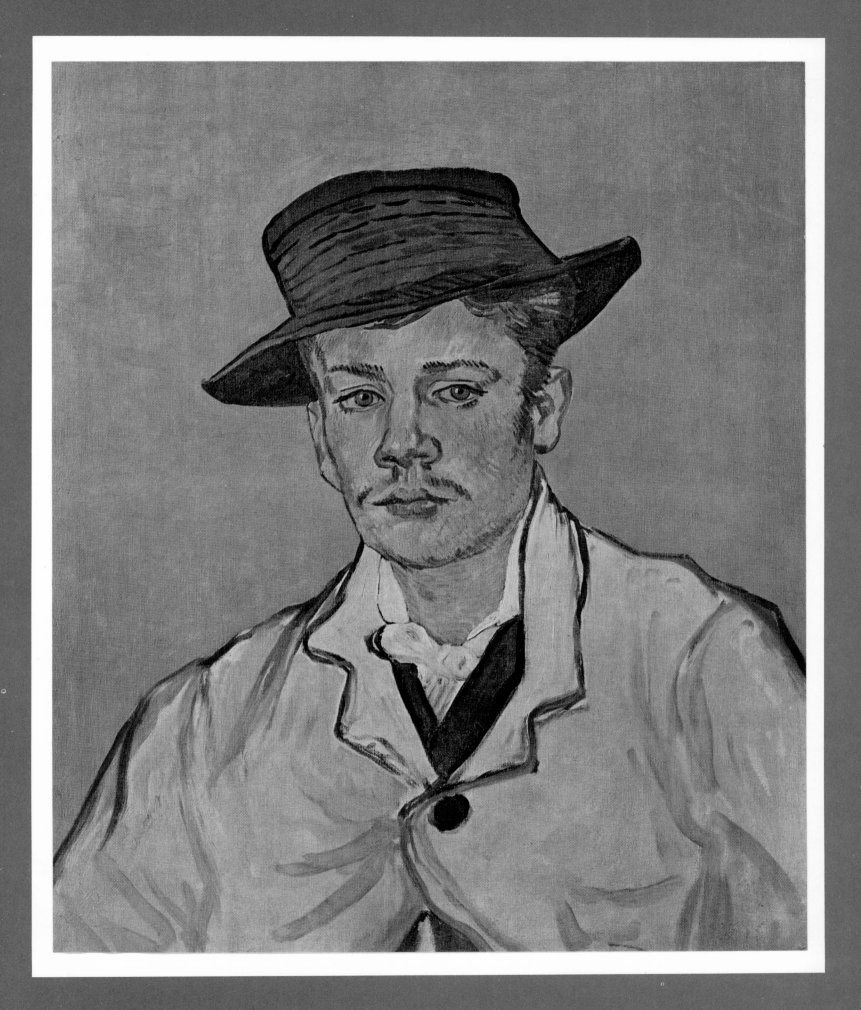

PAINTED IN 1888

After the Bath

OIL ON CANVAS, 45½ × 35″

COLLECTION GEORG REINHART, WINTERTHUR, SWITZERLAND

ALL THROUGH HIS CAREER RENOIR painted the good life, finding in nature and humanity much that was joy-giving. His people are always healthy and beautiful, his landscapes are generally bathed in sunlight and idyllic in character, his still lifes are composed of flowers and fruits—things good to look at and to eat. Referring once to the ancient Greek concept of our earth as a "Paradise of the Gods," Renoir remarked, "Now, that's what I want to paint!"

The female nude reproduced here is typical of his very finest achievement in this genre. Perhaps his own words express best the attitude in which he painted it. His friend and biographer, Ambroise Vollard, quotes him as saying: "My concern has always been to paint human beings like beautiful fruit."

Renoir painted cheerfully, with energy and brilliance, to the very end of his life, even when he was stricken with arthritis and had the brushes fastened to his hands with strips of canvas. Before his death, having won many honors, he was taken for a last tour of the Louvre in a wheel chair, revered now as a "master" by all who saw him. It was on this occasion that it was said of him, in veneration: "There is the Pope of painting."

This judgment represents not only a triumph for Renoir, but for the entire Impressionist movement, which he helped to found.

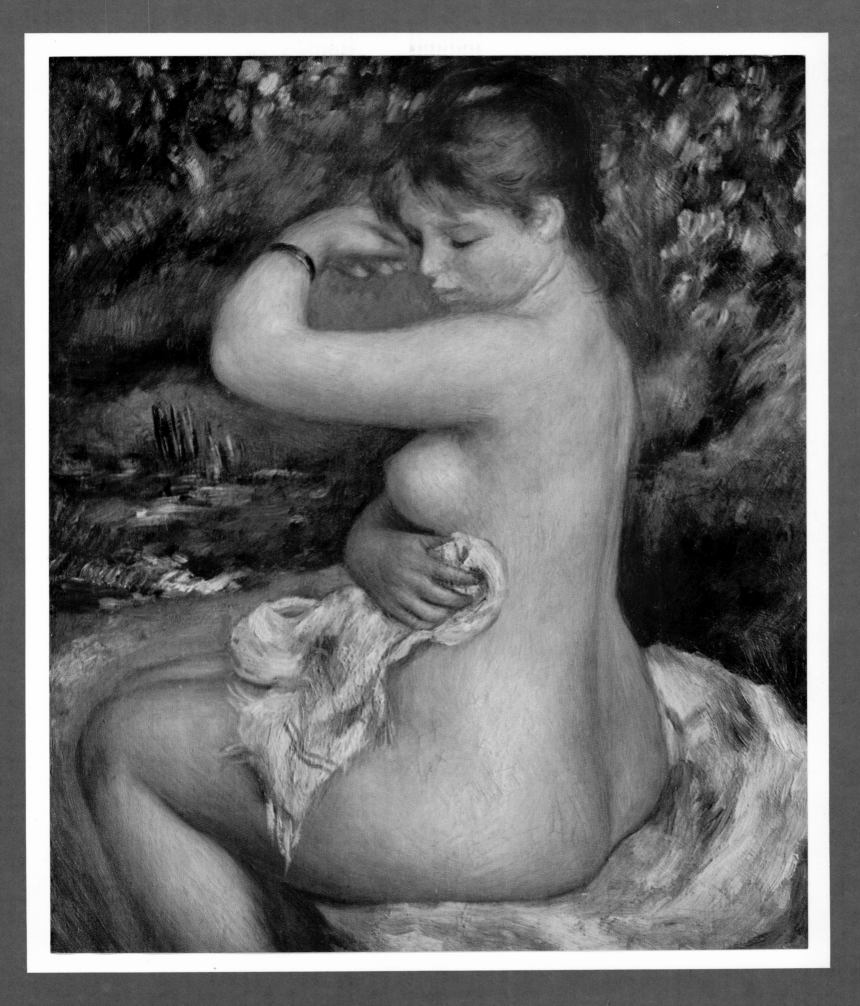

PAINTED IN 1889

The Starry Night

OIL ON CANVAS, 28¾ × 36¼″

THE MUSEUM OF MODERN ART, NEW YORK (*Lillie P. Bliss Bequest*)

IN THIS REMARKABLE PAINTING Van Gogh has removed himself far from the dispassionate, semiscientific mood of the Impressionists. In place of the gentle lyricism of a Monet or Sisley, we have the violence and passion associated with the Expressionist school of a slightly later date, along with a hallucinatory quality which had already been encountered in the dream-pictures of men like William Blake and Charles Meryon.

In the years 1889 and 1890 (the year of his death), the contemplation of a landscape often produced in Van Gogh powerfully emotional reactions which he sought to interpret and restate on canvas. The swirling and writhing brush strokes bespeak torment and agony. The symbolism of a sun and moon combined as one form, the other stars, the "aspiring" cypress trees, we may seek vainly to interpret. If we still remain ignorant of the personal message Van Gogh strove to convey, or the true nature of the emotion which he transferred to pictures, this at least is plain: one of the most remarkable painters of modern times looked for a release from his passionate, tempestuous visions by a transference of these to the material on which he worked. This is not the product of uncontrolled madness, as critics and depreciators had often insisted, for there is a measure of orderliness and planning which even a brief study of the picture makes evident. The lower right-hand portion of the canvas conveys a mood of relative serenity and quiet. The rest suggests a soundless tumult, a restless striving, a desire for "oneness" with nature which almost every critic and layman has immediately sensed. This is the wonder of *The Starry Night*, one of the most unforgettable pictures of our time.

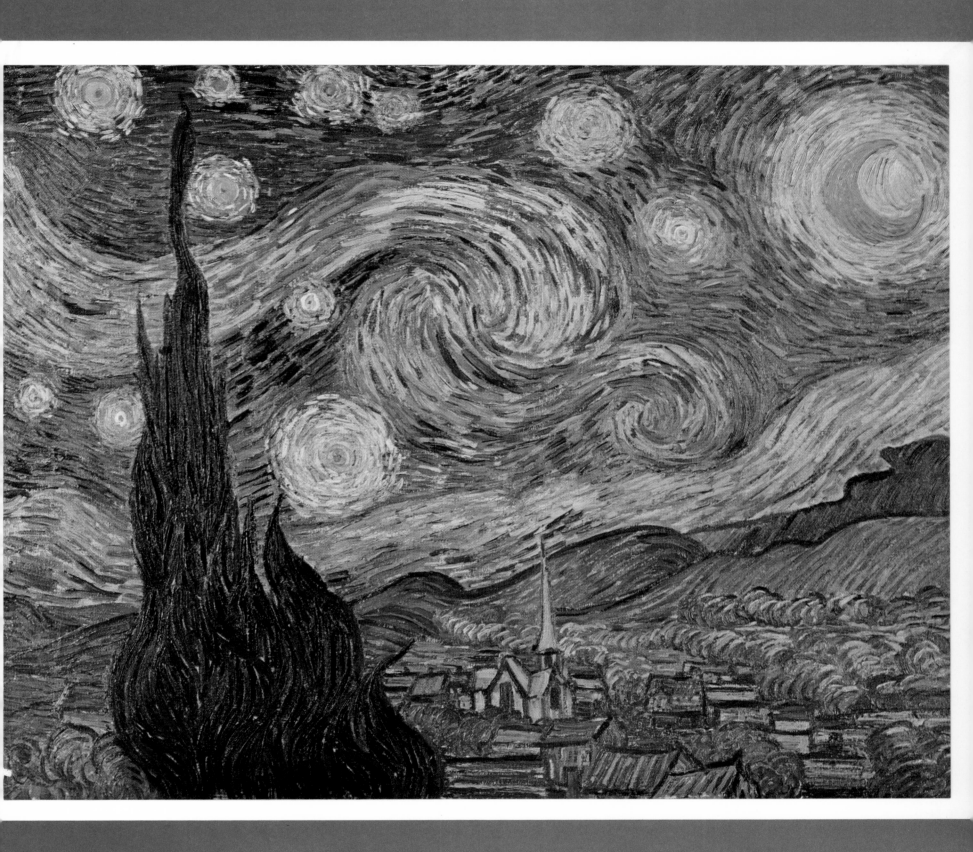

PAINTED 1890–91

The Circus

OIL ON CANVAS, 72⅞ × 59⅛″

MUSEUM OF IMPRESSIONISM, THE LOUVRE, PARIS

OBSESSED WITH SCIENTIFIC THEORIES, Seurat studied chemistry, geometry, and the laws of optics. Patiently he applied his science to the canvases which he covered with dots and small daubs of pure color, juxtaposing them according to his principles, so that the desired mixture and blend was made in the eye of the observer. Certainly this method, described as Neo-Impressionism or Pointillism, was not very different from that employed by Monet and Sisley. Pissarro for a while became an enthusiastic supporter, but ultimately found limitations in the method. Gauguin also made a few experiments with the technique, but later derided the "little green chemists who pile up tiny dots."

It was only with the later generation which produced the Cubists that Seurat came into his own. They ignored his "chemistry" but took instruction from his careful, thoughtful, almost mathematical construction of a picture, where, without drawing or modeling in the conventional sense, the shapes assumed clear silhouettes and took on form and volume.

It is significant that, just after Seurat's death, the far-seeing Pissarro wrote to his son, Lucien: "I went to Seurat's funeral yesterday. I saw Signac there; he was terribly broken up by the loss of his friend. I think you're right, Pointillism has had its day; but I suspect that it will have effects of much importance on the future of art. Seurat obviously has made a definite contribution."

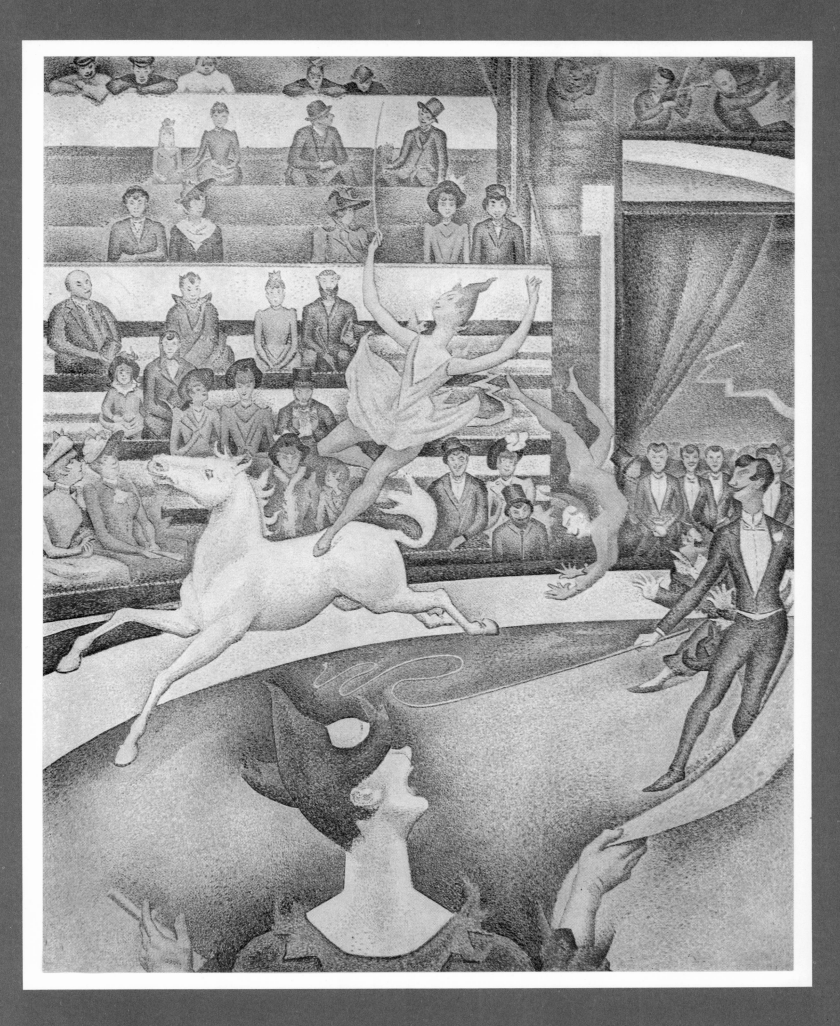

PAINTED IN 1892

Fatata Te Miti

OIL ON CANVAS, 26¾ × 36″

NATIONAL GALLERY OF ART, WASHINGTON, D.C.

(Chester Dale Collection)

PAUL GAUGUIN IS GENERALLY CONSIDERED a member of the Impressionist group, although on first appraisal his canvases seem so dissimilar in technique and subject matter from those of other painters in the school. It is not generally known that this strange iconoclast was one of the first patrons of the men who founded the movement; during the early days of their struggle, he met with them at the cafés and painted with them on Sundays and holidays. Not yet turned professional painter, he earned substantial amounts of money as a successful broker on the Paris Exchange. During this period of affluence he acquired works by Manet, Monet, Cézanne, Sisley, Pissarro, Renoir, and others. By 1876, after some four years of diligent painting, he had a canvas accepted by the Salon. This success caused him to neglect his work at the Bourse.

In 1883 he gave up his business and decided "to paint every day." This produced misunderstandings with his Danish wife and her family. Gauguin's "eccentric" period was about to begin. This aspect of his career has been amply, perhaps too amply, dealt with in various romantic biographies written about him.

Not many of Gauguin's paintings are Impressionistic in the same sense as those of Sisley, Pissarro, Monet, or Renoir. He came close to them spiritually in his desire to break with academic traditions and paint the world around him. He went further than most of them in his efforts to seek out the exotic, to paint in strong, flat colors, and to achieve the broad, bold, decorative patterns made popular by the circulation in France of the Japanese wood-block print. Whereas later painters began to borrow from African masks and carvings, Gauguin went directly to primitive sources, traveling to Tahiti and Martinique, where he mingled with the natives and shared their experiences and ways of life.

Thus, with Gauguin, Impressionism as a technique was a passing, half-realized phase. But without a knowledge of its principles and without a kinship with its disciples he could never have painted the scene here reproduced.

The painting which bears the title *Fatata Te Miti* was painted in 1892, just nine years after Gauguin had turned professional. He was physically at a low ebb and had previously written dejectedly to his friend Daniel de Montfreid describing how he would spit up a quarter of a liter of blood daily, that he was lacking in energy, and that in "an astonishing way" he had grown much older "all of a sudden."

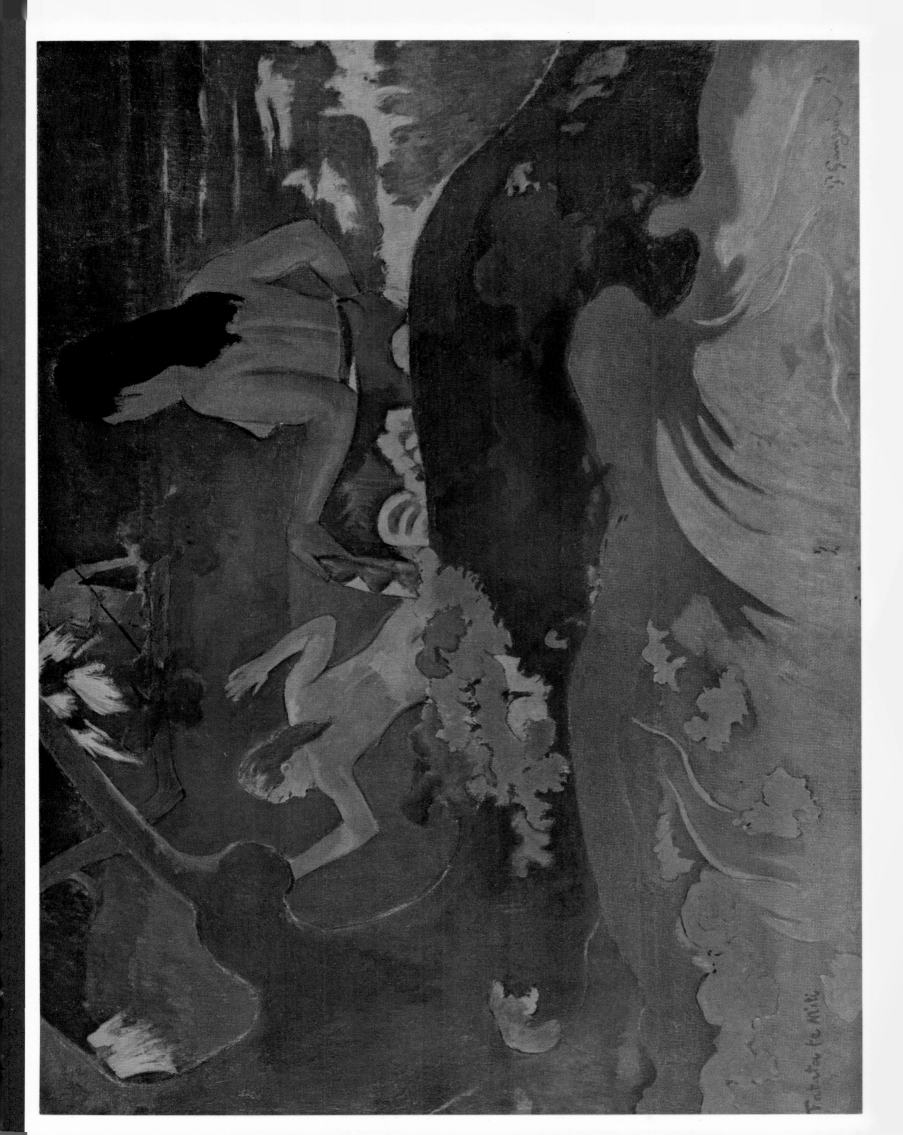

PAINTED 1895–1900

Still Life with Apples and Oranges

OIL ON CANVAS, 28¾ × 36¼"

MUSEUM OF IMPRESSIONISM, THE LOUVRE, PARIS

PAUL CÉZANNE DIGNIFIED THE STILL LIFE as had no other artist of his time. Apples, oranges, water pitchers, and tablecloths are endowed by him with a significance rarely given them by other painters. He eschewed the trickery of *trompe l'oeil* painting and refused to make a cup or vase an attractive auxiliary "prop," as did Manet or Renoir in so many of their compositions. For Cézanne these everyday objects were part of nature, and the fruits and mugs furnished him with the wonderful spheres and cylinders of which he spoke so constantly and which he sought in the landscapes of Aix and L'Estaque.

Endlessly he arranged these familiar objects on a cloth-draped table; he rendered them with the same seriousness as he did his human models. Simple objects are transformed and ennobled. The "architecture" of the compositions, the subtle transitions of color and tone combine to evoke in the onlooker sentiments usually engendered only by the contemplation of landscapes or portrait studies. The picture here reproduced is a superb example of his ability to do this.

Further simplification of Cézanne's still-life compositions was destined in the following decades to pave the way for the abstractions of Braque and Picasso. Today he is respected for having made a profound and lasting contribution to art's development, but during his most productive years there was slight recognition of his genius.

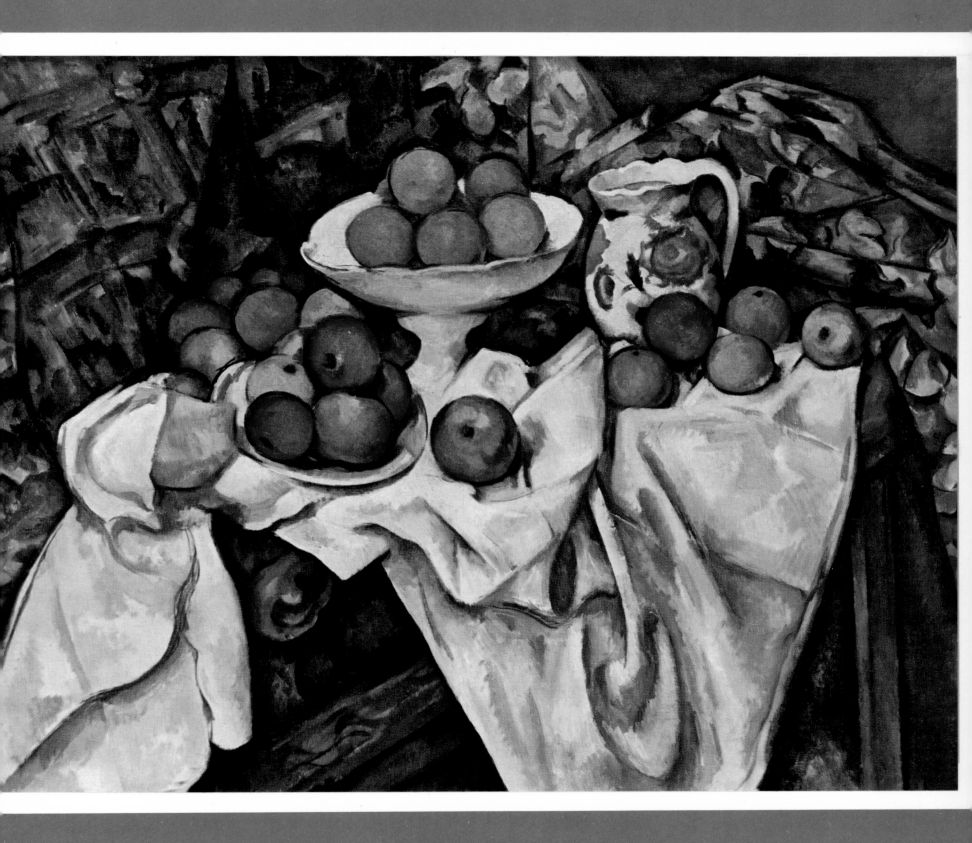

PAINTED IN 1897

La Grande Loge

OIL ON CARDBOARD, 21¼ × 18¼″

COLLECTION METTLER, ST. GALLEN, SWITZERLAND

HENRI DE TOULOUSE-LAUTREC, who was born in Albi in 1864, has been described by many whose path he crossed in the course of his brief life. Among these were artists, poets, novelists, dancers, and other entertainers of various categories. His "profile" was an unforgettable one. He has been called a "dwarf of Velázquez," a "little monster," an "abortion," a "hunchbacked Don Juan."

Until he was almost fourteen the young Henri was a normal child, normal in the sense that, although fragile, his physique was like that of other children of his age. There is an early sketch, a self-portrait, if you will, where he represents himself with legs quite in proportion with the rest of his body. In 1878 he slipped on a hardwood floor and broke a thighbone. A year later, while on a walk with his mother, he fell into a shallow gully and broke the other leg. The bones never mended properly and his legs did not develop normally, whereas the torso did. He knew soon that he was destined to be crippled and deformed. In all future self-caricatures Lautrec exaggerated the disproportions of his pathetic physique.

The period of greatest productivity for Lautrec was the ten-year stretch when he lived in his astonishing studio on the rue Coulaincourt, 1887–97. Many of his contemporaries have left colorful anecdotes of his escapades during this period, making it seem incredible that any time was left for work. This is the period of his nocturnal journeys through Paris, of his Gargantuan absorption of liquor—every conceivable ingredient going into the "cocktails" which he mixed for himself and his visitors. During these days and nights he visited the race track, the hospitals (to witness surgical operations), the law courts, the circus, the music halls and dubious "night clubs." Of all this he has left us a graphic record, reflecting itself in different media. He made posters for Aristide Bruant and others; he lithographed menus, song sheets, and theater programs. He illustrated books and did suites of lithographs for portfolios. He made sketches for magazines like *Le Rire*. He painted portraits of writers and whores. He rarely read or wrote letters, but rendered his life in pictures. He worked always with a feverish intensity, like a man who knew there was little time left.

The painting reproduced here is typical in its accurate, unflattering representation of two women who are obviously attempting to appear quite "elegant" while seated in a large theater box. The raw, almost unpleasant colors in which the scene is represented are typical of the palette which Lautrec made his very own.

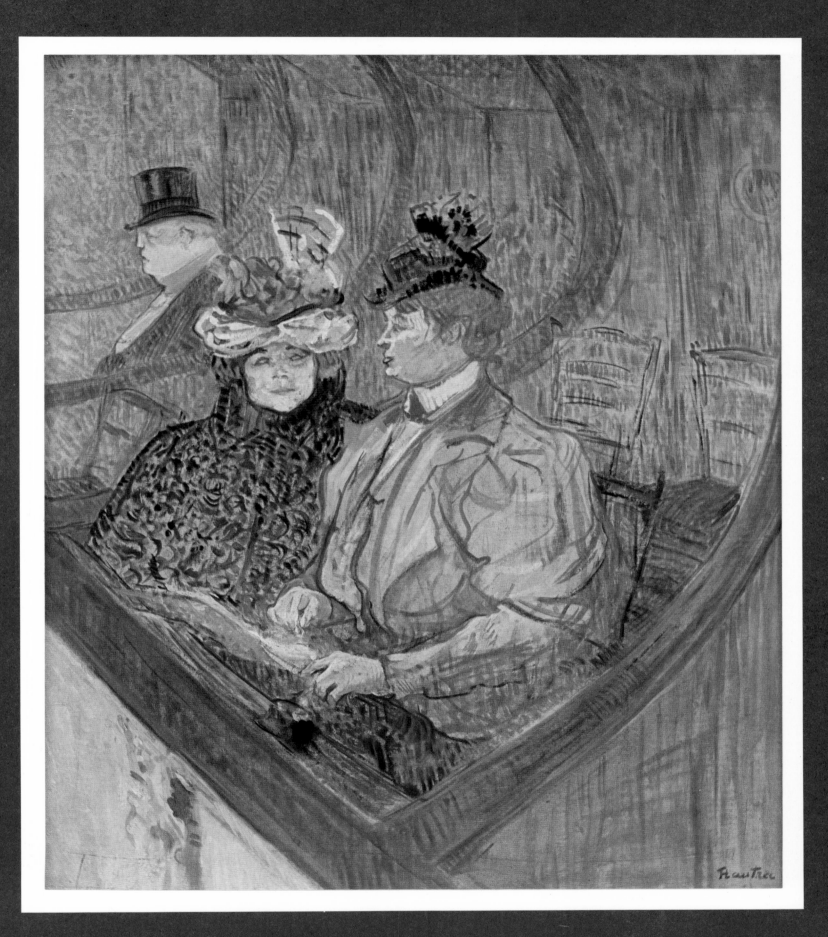

PAINTED IN 1880

Peasant Woman

OIL ON CANVAS, 28¾ × 23½"

NATIONAL GALLERY OF ART, WASHINGTON, D.C.

(Chester Dale Collection)

CAMILLE PISSARRO MIGHT VERY WELL be called the "elder statesman" of the Impressionist group. A man of great dignity and restraint, he won the admiration of his fellow artists who listened to his learned and articulate exposition of art theories when they gathered nightly at the favored Paris cafés. Mary Cassatt, the distinguished woman painter of the group, once commented that Camille was so great a teacher "that he could have taught stones to draw correctly."

Pissarro's life was uneventful when compared with the drama-filled careers of Gauguin and Van Gogh, but it was surely not without tragedy. When the Germans briefly occupied Paris in 1870, they looted his studio in nearby Louveciennes and left only about forty of some fifteen hundred canvases, the fruit of many years of painting. The invaders had used his pictures as rugs to cover the garden mud.

Pissarro was born at Saint Thomas, in the West Indies, and was sent to Paris by his shopkeeper family to complete his education. As a boy he had evinced a great love for the artist's craft, making endless sketches of the people and the colorful sights of his native town. It was not until he was twenty-five, however, that his family consented to his giving up business for the questionable profession of an artist. He arrived in Paris in 1855, when a great World's Fair was being held, and had the opportunity to see distinguished paintings from all over Europe. He was most impressed by Corot, came to know this kind and patient man, and was long influenced by him. He later succumbed to the viewpoint of the stormy realist, Gustave Courbet, which produced a break with Corot. More profound and lasting influences came from his association with Cézanne, Manet, Degas, Renoir, Monet, and Sisley, the men who formed the new movement under discussion. In 1870, he made a trip to England and absorbed a good deal from a study of the paintings of Turner and Constable.

Primarily Pissarro remains the painter of nature, the countryside being a constant source of inspiration for him. Adopting the methods of this "out-of-doors" school, he represented fields, river scenes, and the woodland, revealing the same quiet understanding of nature that is reflected in his beautiful letters to his son, Lucien.

Toward the end of his life, however, he had trouble with his eyesight and was unable to paint out of doors. Seated in a hotel room, he watched the bustle of a busy city street through the open window. This aspect of contemporary life he also loved deeply, and he painted many impressions of the boulevard's life, translating its color and movement to some memorable canvases.

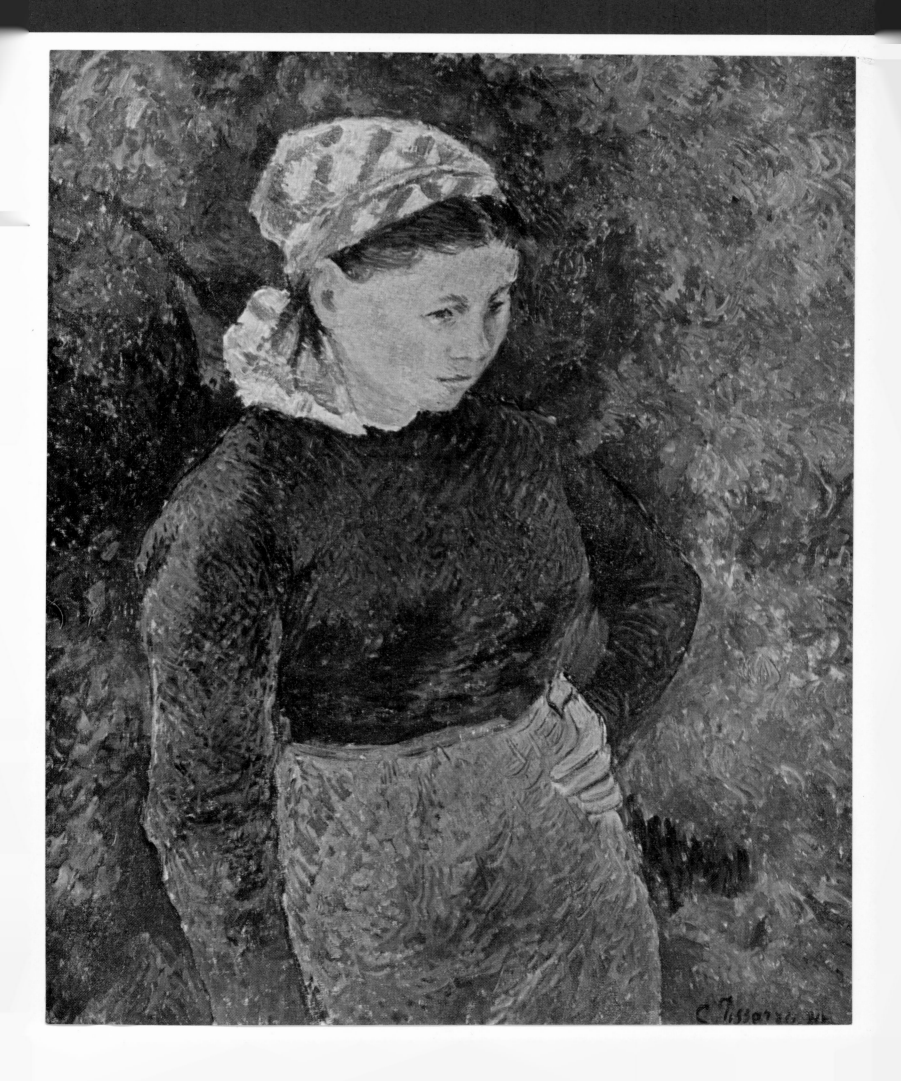

CLAUDE MONET (1840–1926)

PAINTED IN 1873

Field of Poppies

OIL ON CANVAS, 19⅝ × 25⅝″

MUSEUM OF IMPRESSIONISM, THE LOUVRE, PARIS

THERE IS EVERY GOOD REASON to think of Claude Monet as the dean of Impressionism, for he tenaciously held to its theory and practice during the long years of his career. For him it was not a mere phase of his artistic career, nor a series of rules and precepts to be followed only in part, as was the case with most of the other members of the group.

Ignoring harsh criticism and epithets, he staunchly divided his pure spectrum colors according to the school's teachings. Seated before his diverse subjects, whether haystacks, a cathedral façade, or a country landscape, he transferred what his eye saw to canvas; for this, in part at least, was the kernel of Impressionist teaching. This school was concerned with light and with the effect of light on those objects which it bathed or illumined. Partially these artists drew on their growing knowledge of the laws of optics, which caused them at times to be called "mere scientists." But Monet learned most by scrutinizing the changing universe and noting down with brush and color the transitory aspect of things as the sun rose and set. When a brilliant light so bathed an object that its outlines became vague and undulating, with colors not clearly defined from one another at their edges, he tried to paint what the *eye saw* and not the aspect of the object as the *mind knew it to be*. This was a far cry from the academic convention of drawing from the over-familiar casts and studio arrangements. It was this very attempt at a complete veracity of statement which shocked most of the critics of the time and brought Monet the title of "faker" and "madman."

Today, when we consider a picture such as the one reproduced here, it seems incredible that this kind of painting could so have shocked the art world of less than a century ago. For here is a field of poppies, the colors true to nature, the draftsmanship comprehensible to all. Such a picture no longer produces "jeers and boisterous laughter," as it did in the days of George Moore, who describes in his *Confessions of a Young Man* the reactions of critics and the public at the opening of the Impressionist exhibit.

Currently many of Monet's pictures hang with those of the other co-makers of Impressionism in the Museum of Impressionism, the Jeu de Paume, located in the gardens of the Tuileries and considered as part of the Louvre. Close by, in the special Orangerie Museum, there are two oval rooms decorated with a continuous mural depicting the lily ponds just outside Monet's last house at Giverny. Using the familiar and much-loved site, he transferred the ephemeral and transient aspect of this garden spot into one of Impressionism's lasting monuments.